SHEEP'd

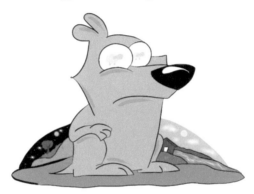

"Your talent is GOD's gift
to you; what you do with it
is your gift to GOD."
– Leo Buscaglia

By
L.W. Willard

To my wife, Leah and my children: Cheyenne, Chandler, Lillian, Elijah, & Logan.
I love you all so very much!!

A very special thanks to Lana Marthiljohni & Lauren Thornhill

WestBow Press books may be ordered through booksellers or by contacting:

WestBow Press
A Division of Thomas Nelson & Zondervan
1663 Liberty Drive
Bloomington, IN 47403
www.westbowpress.com
1 (866) 928-1240

ISBN: 978-1-4908-7891-1 (sc)
ISBN: 978-1-4908-7892-8 (e)

Library of Congress Control Number: 2015907196

Print information available on the last page.

WestBow Press rev. date: 6/15/2015

WESTBOW
PRESS
A DIVISION OF THOMAS NELSON
& ZONDERVAN

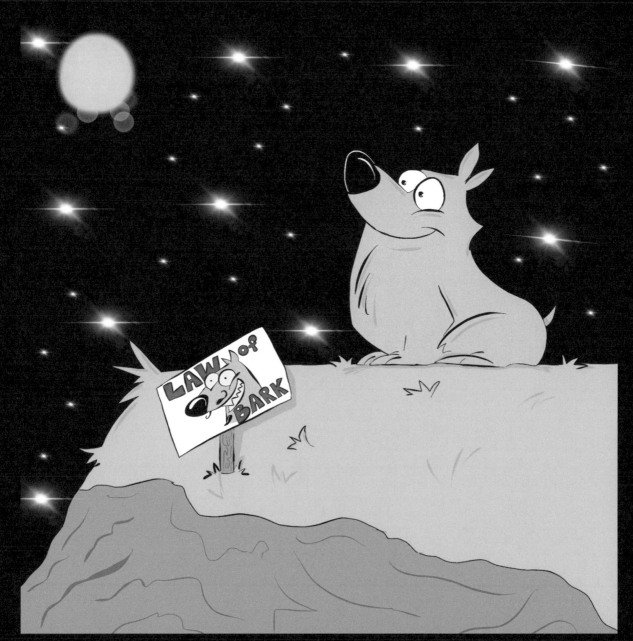

Once upon a time in a land ruled by the bark,
a wolf sat alone, alone in the dark.

"The moon looks amazing
illuminating the night,"

Walter thought to himself
while admiring his sight.

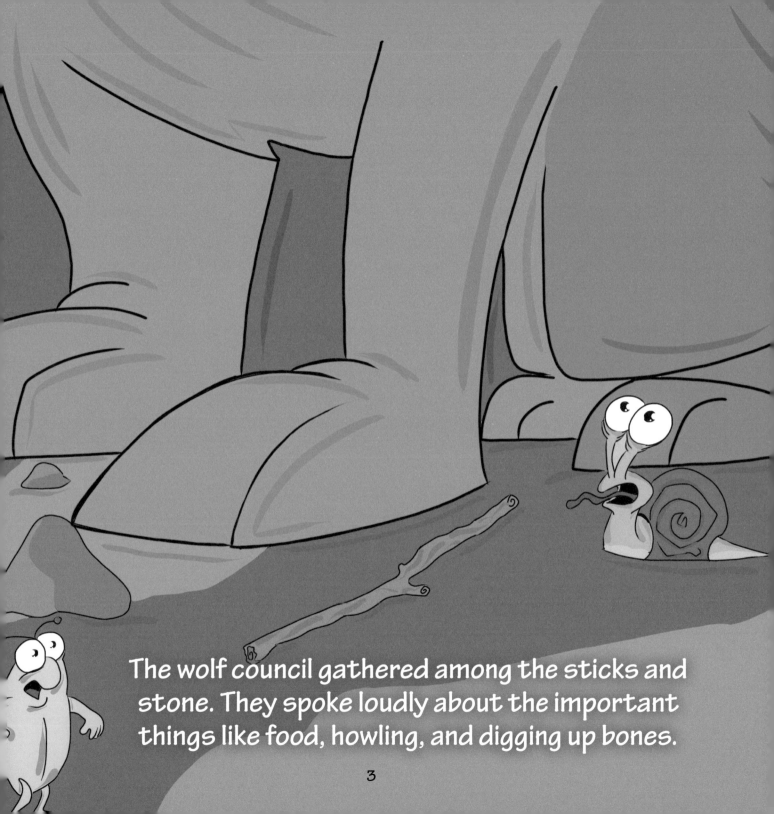

The wolf council gathered among the sticks and stone. They spoke loudly about the important things like food, howling, and digging up bones.

3

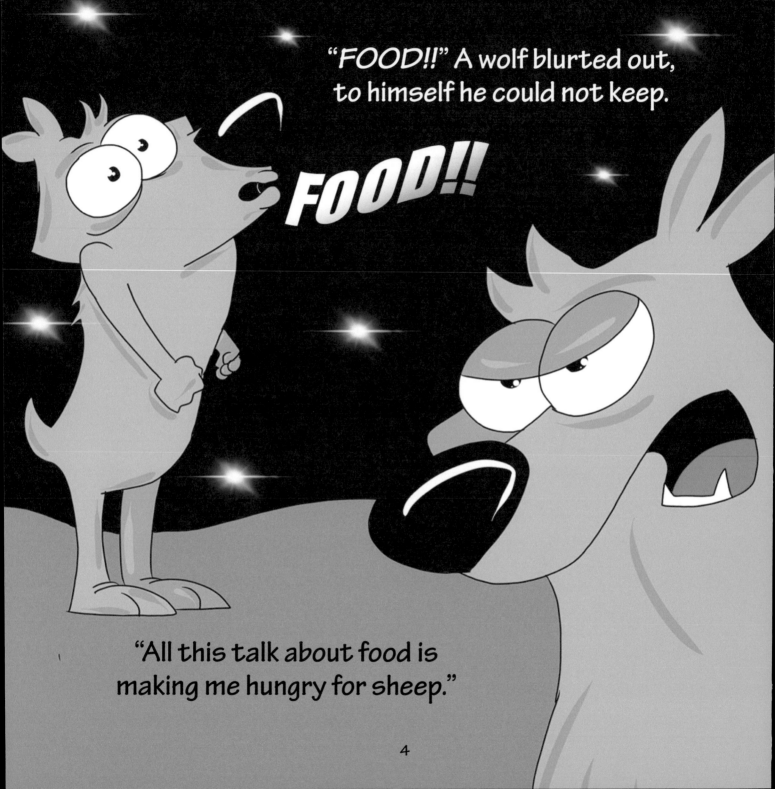

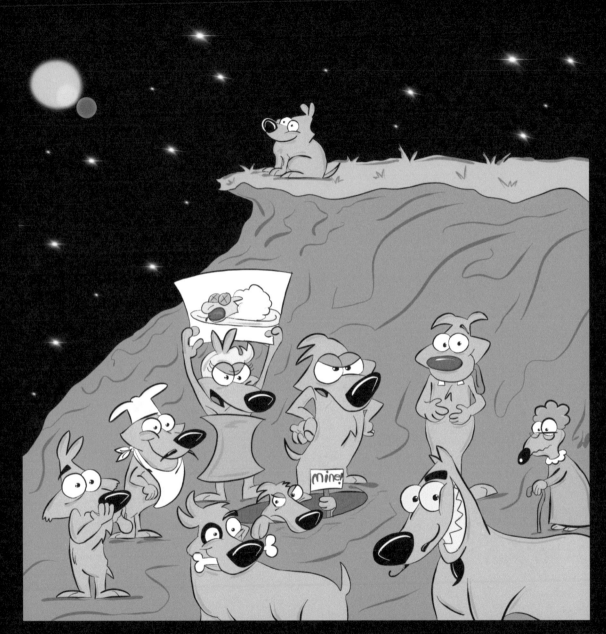

The pack looked to their leader hungry for a solution;
the alpha wolf smiled while feeding into their delusion.

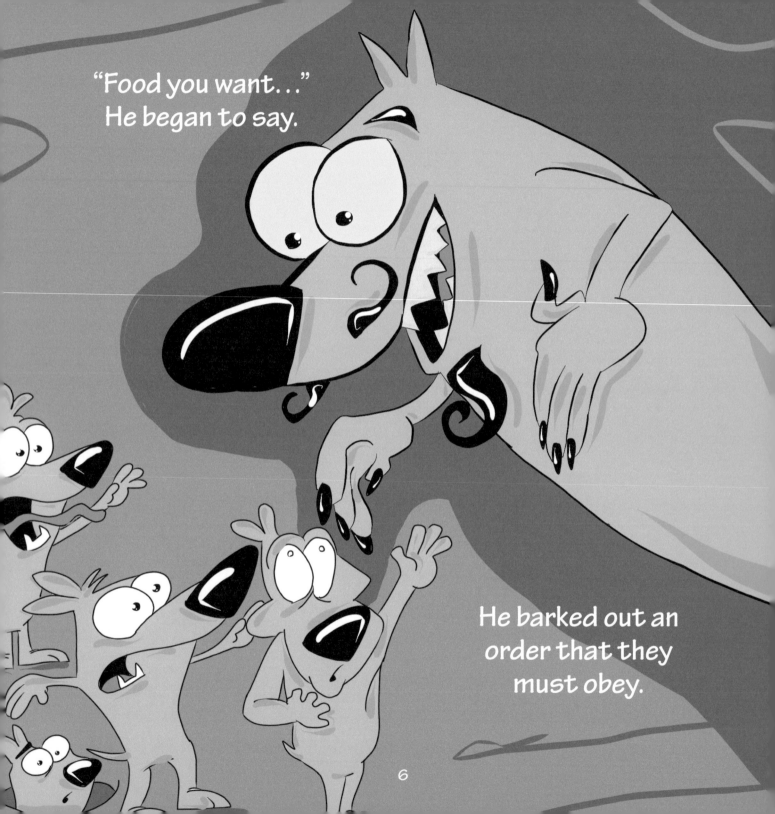

"Food you want…"
He began to say.

He barked out an
order that they
must obey.

6

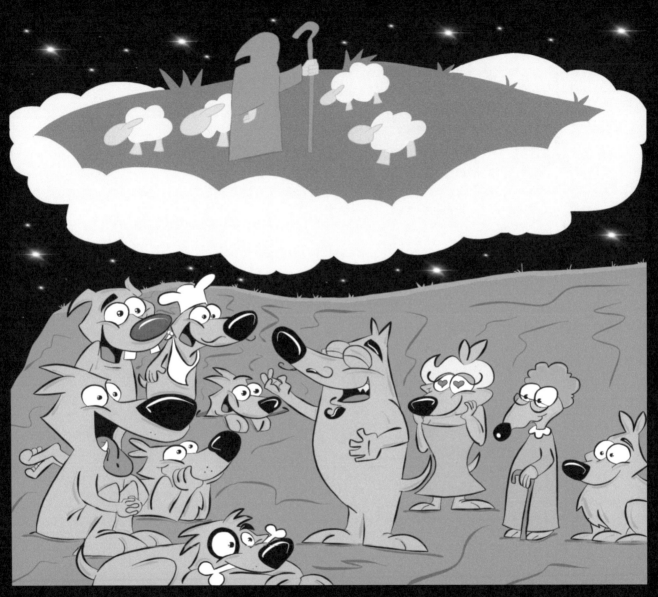

He spoke of a mythical land that was told to him by his Gam Gam. Guarded by one shepherd, making it easy to nab a lamb...lamb.

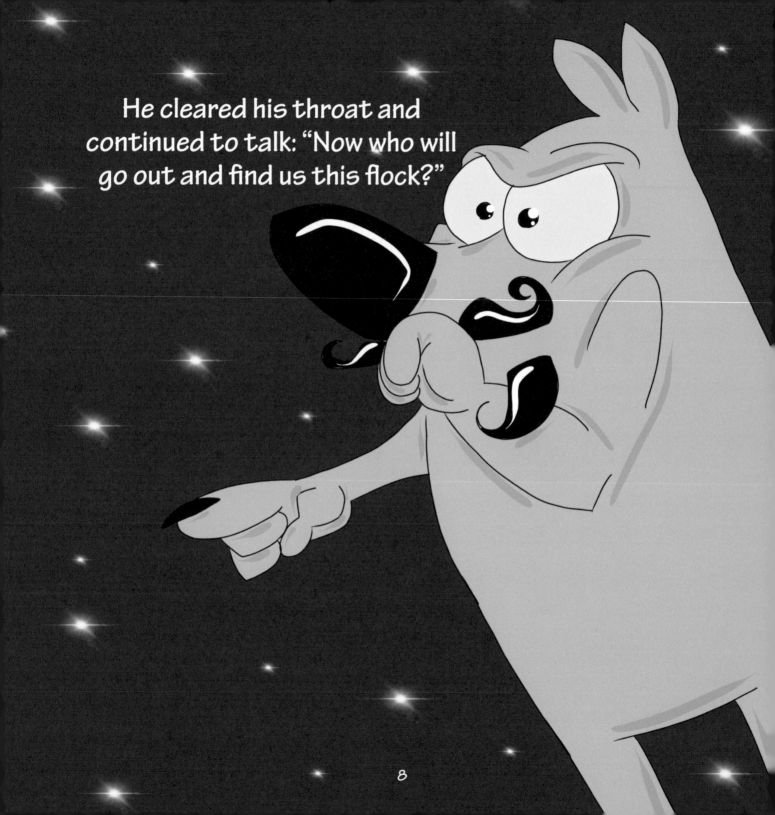

He cleared his throat and continued to talk: "Now who will go out and find us this flock?"

"I will *go out.*" Walter said to himself.

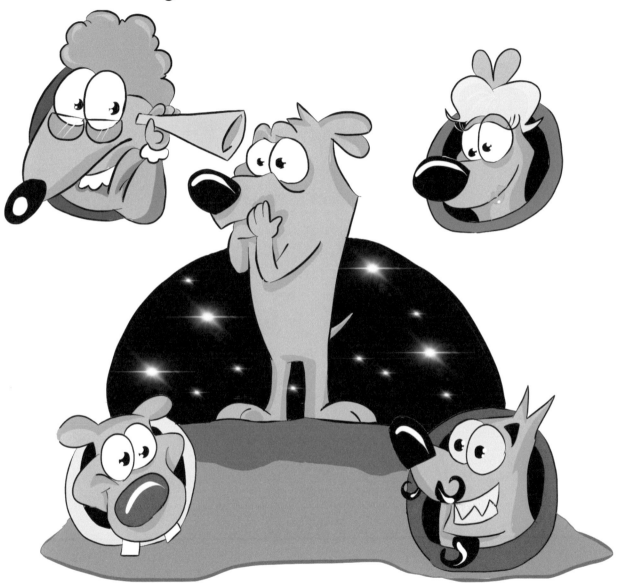

It then got really quiet, so guess who heard him. That's right, everyone else.

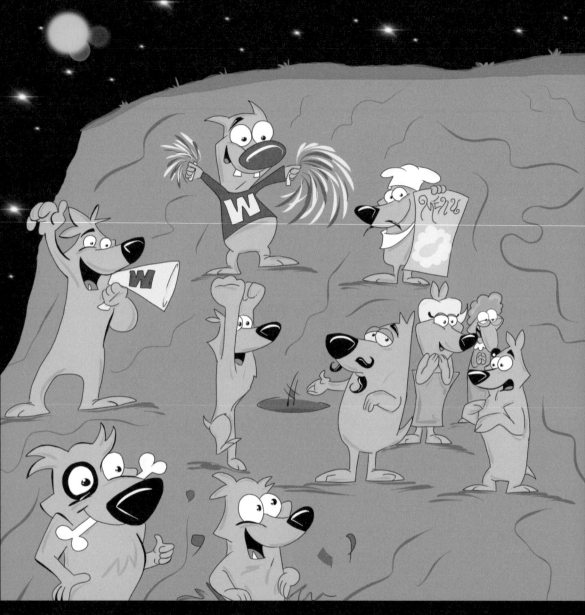

"Walter! Walter!" The pack cheered him on;
he thought to himself, "What have I done?!"

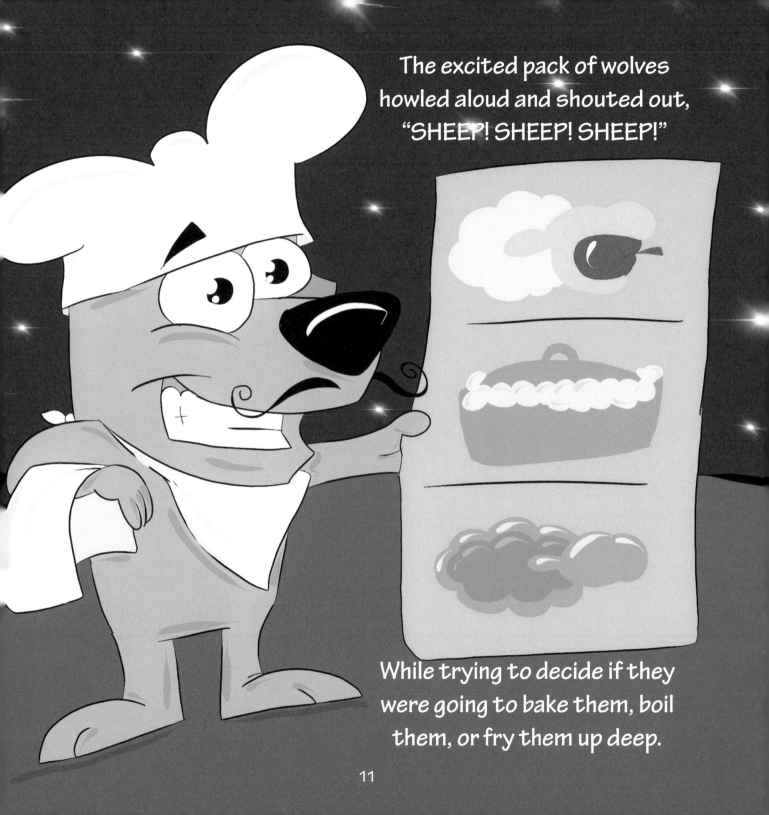

Walter knew that he had to leave right now.
He picked up his feet and let out a howl.

By the light of the moon, Walter began to run.
For awhile he thought, "this is pretty fun."

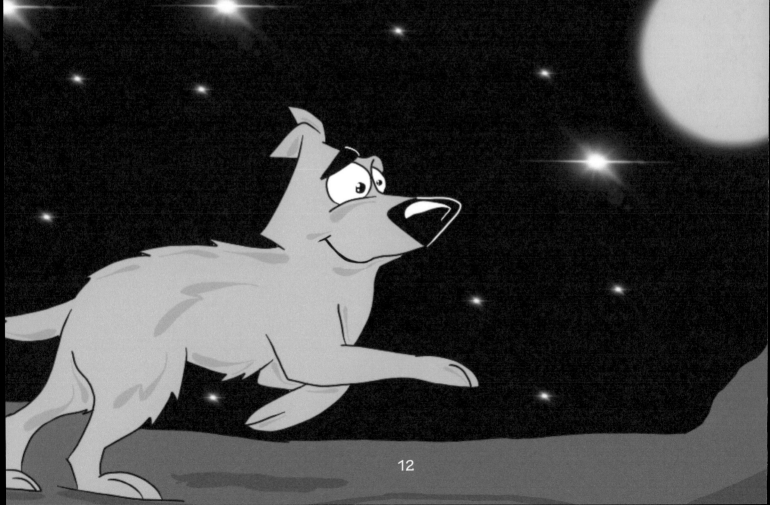

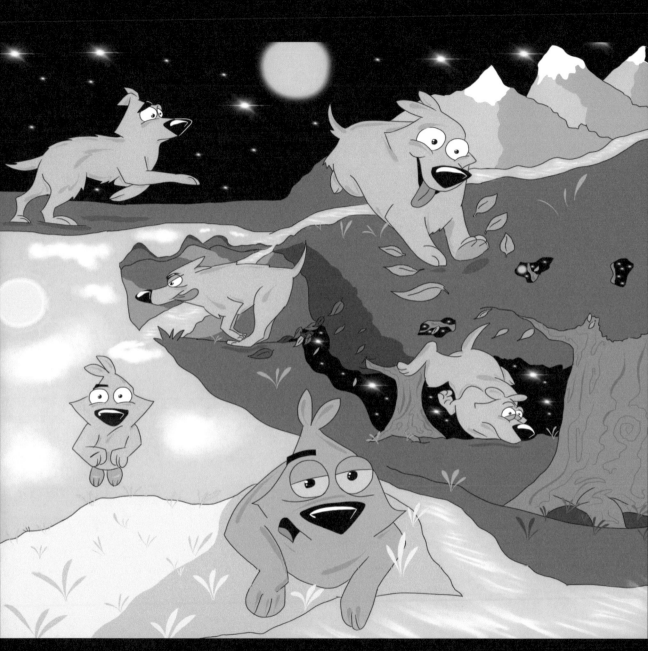

Mountains and valleys and rivers he crossed,
the night was so dark he began to feel lost.

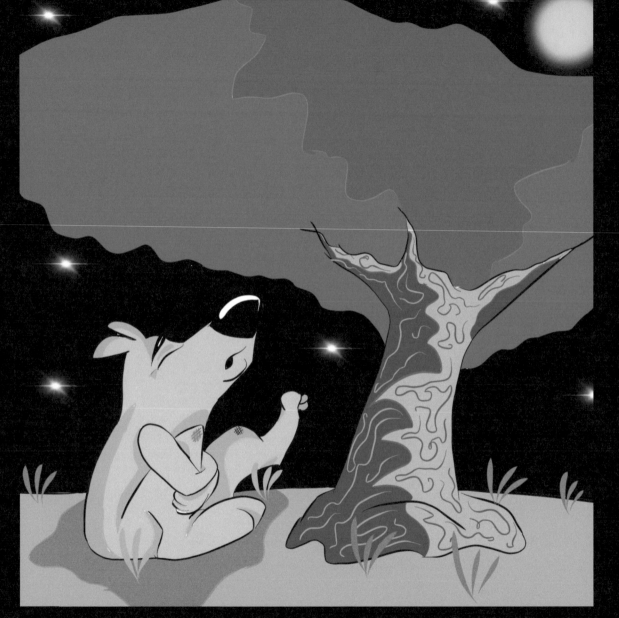

The moonlight was sometimes hiding above the trees;
Walter took a few wrong steps gashing up his knees.

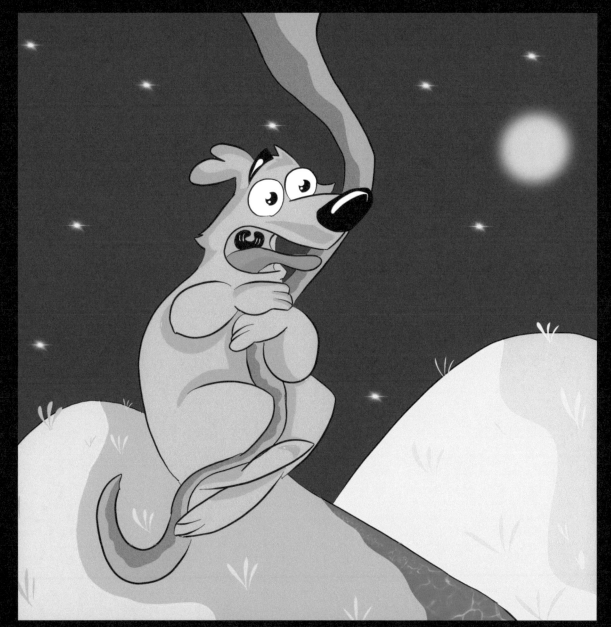

Running through the hills and streams and fields of hay;
Walter began to feel as though he had lost his way.

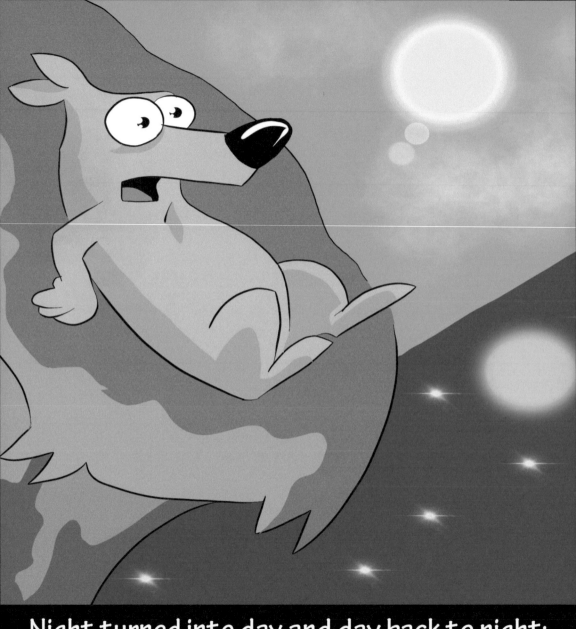

Night turned into day and day back to night;
Walter continued on with all of his might.

Finally, he ran till he could run no more.

His eyes caught sight of a huge cloud,

but this cloud was on the floor.

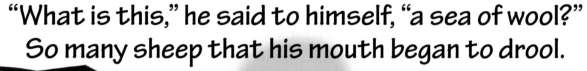

"What is this," he said to himself, "a sea of wool?"
So many sheep that his mouth began to drool.

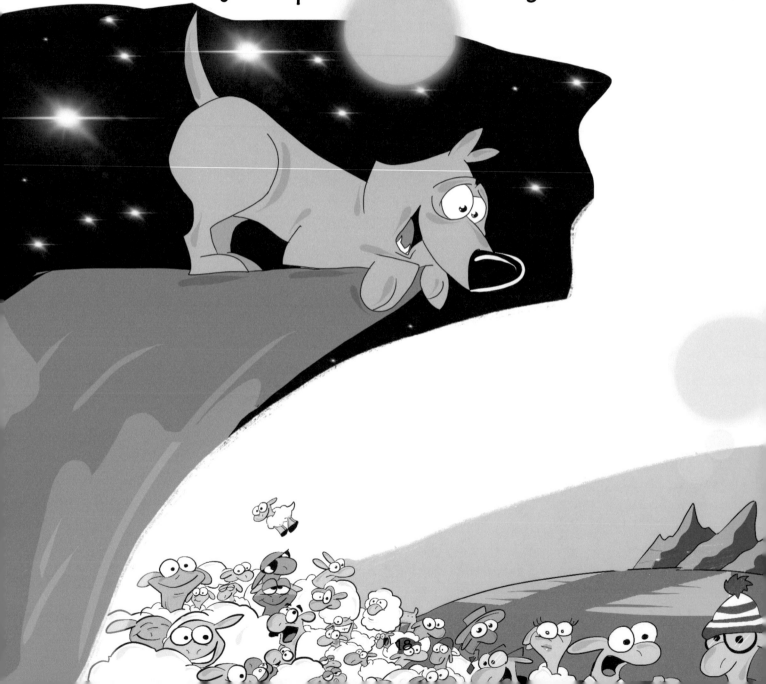

Walter stood in front of a tree that perched an owl,
looked to the moon and released his howl.

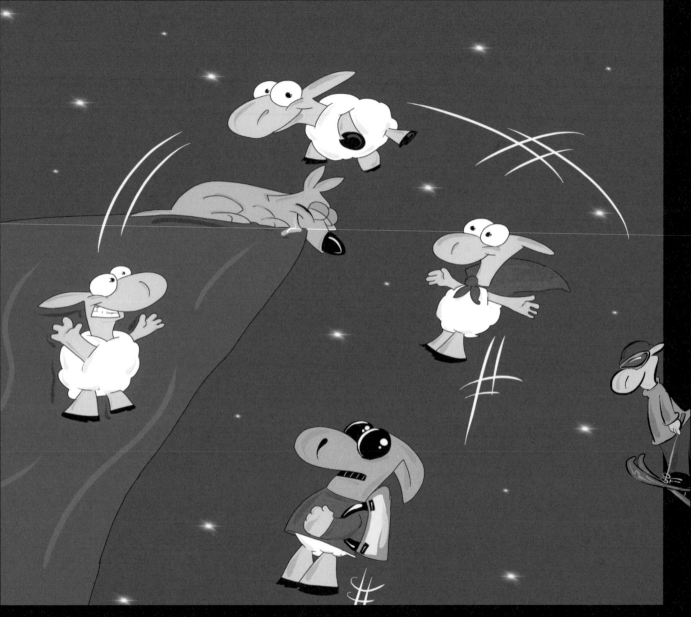

One sheep, two sheep, three sheep, four...
He counted so many sheep that he began to snore.

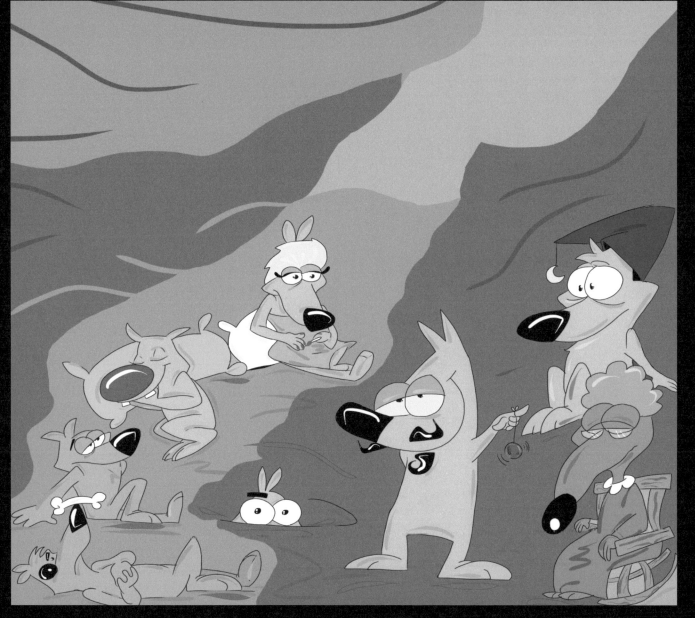

Meanwhile, back at the chaos and muck,
the pack of wolves wondered if Walter had any luck.

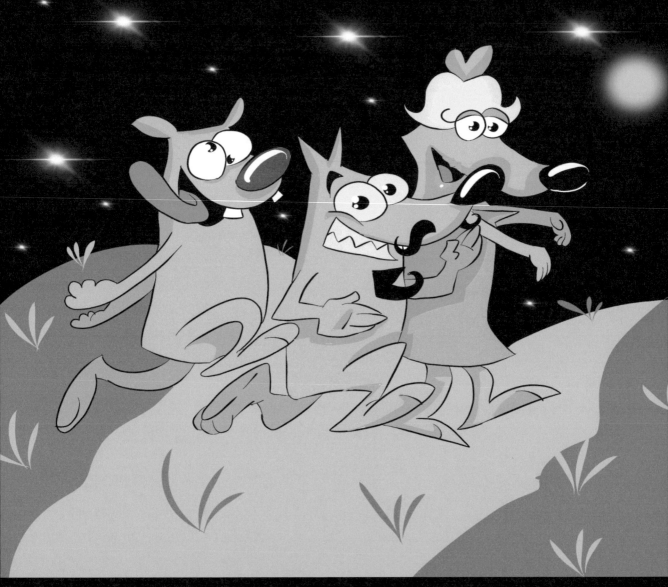

Tired of waiting around with nothing to do;
as a pack, they set out to follow, you know who.

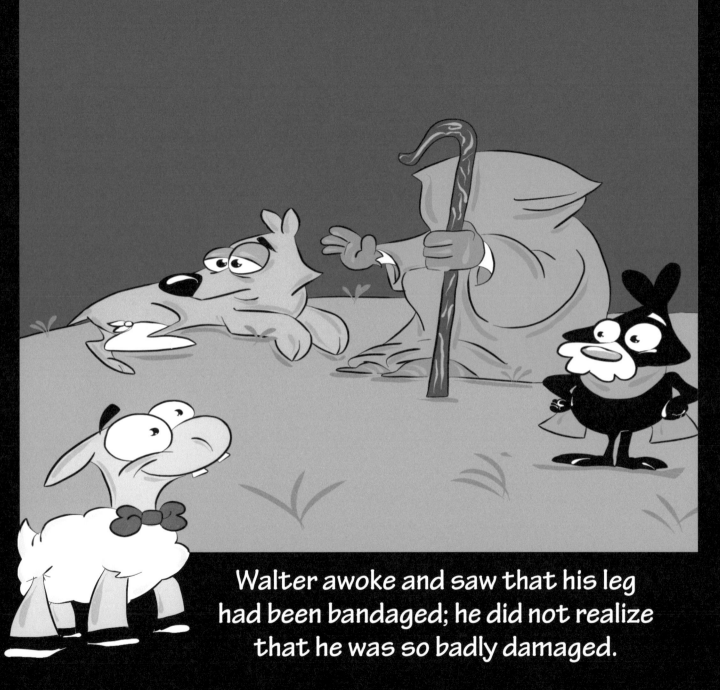

Walter awoke and saw that his leg had been bandaged; he did not realize that he was so badly damaged.

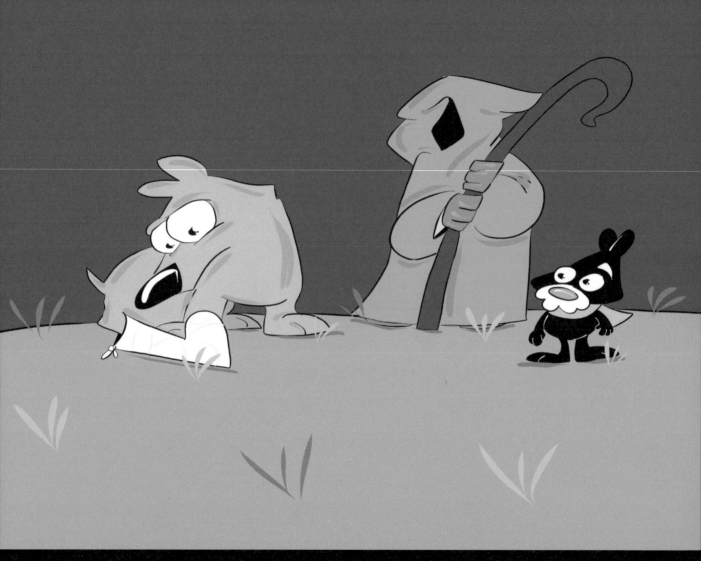

"Be patient young pup," he heard someone say;
"This is my land and I am the way."

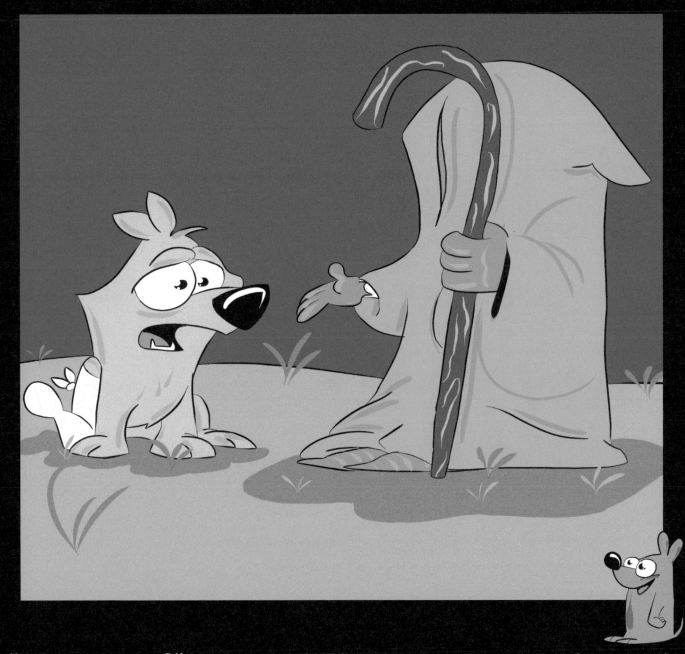

"Who are you?" Walter asked trying not to sound scared.
"The bandage over your wounds for I am the one who cared."

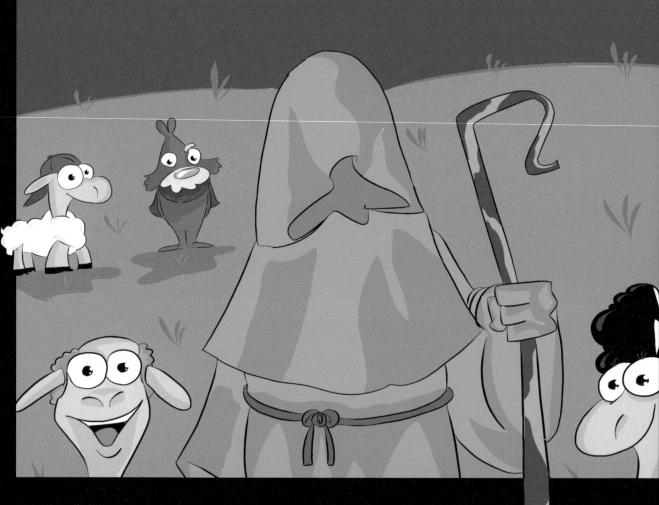

"I am the shepherd and these are my sheep;
their protection from wolves, I alone keep."

"Your journey here was dangerous and rough, you traveled alone; you must really be tough.

There is more to you than even you can see. Walk among my sheep, walk around, be free.

There is some food for you in that red dish. I hope you don't mind fresh bread and fish."

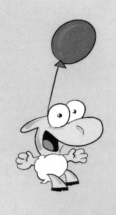
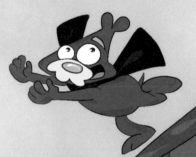
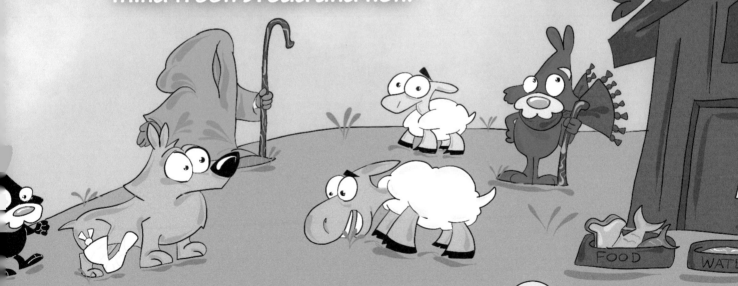

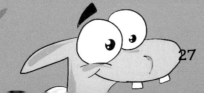
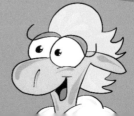

FOOD

WATER

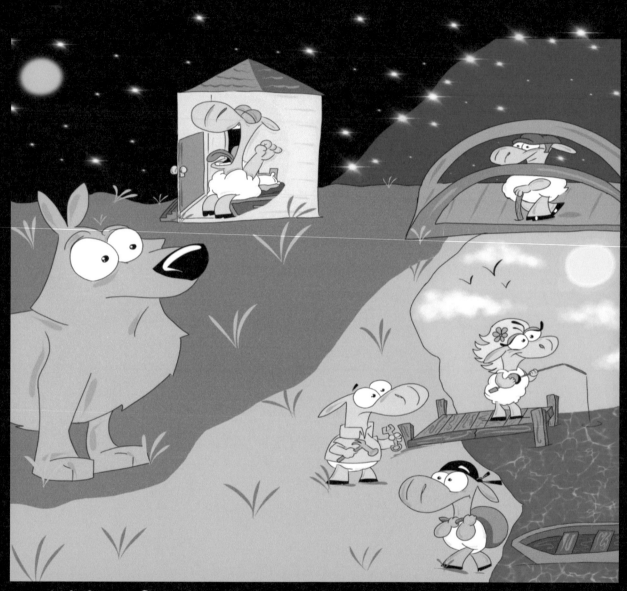

Walter finished his bowl and began to explore.
Walking and talking with the sheep,
he realized that they were so much more.

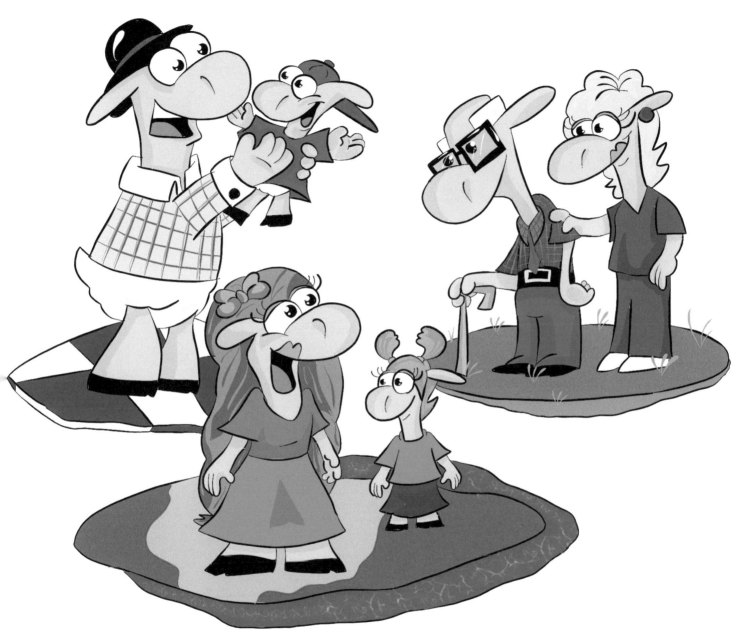

They are fathers and sons, sisters and brothers,
uncles and aunts, daughters and mothers.

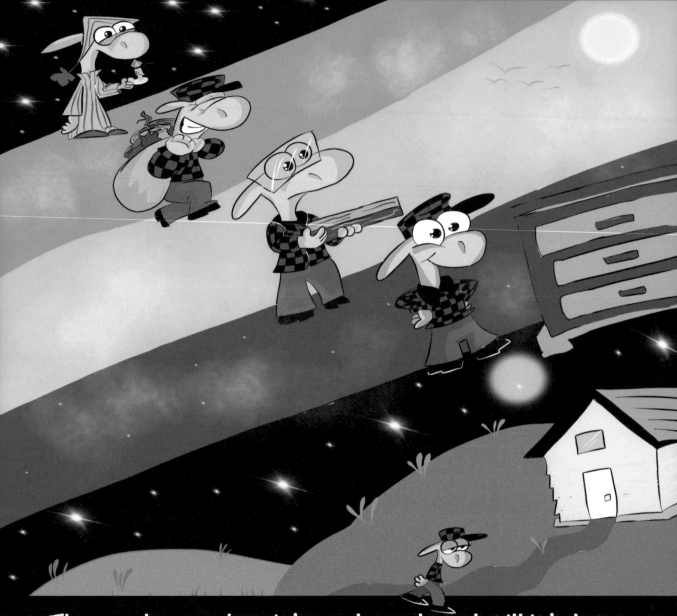

They wake up when it's early and work till it's late;
their way might seem hard, but boy is it great.

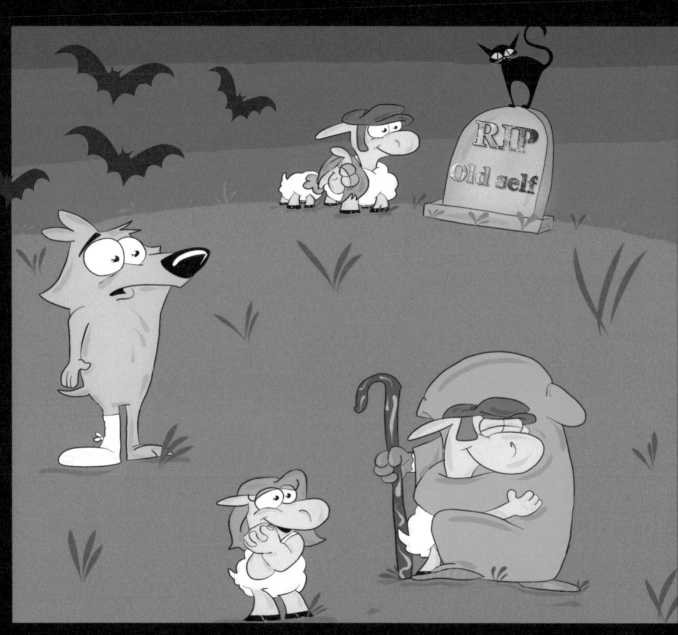

Their sacrifice was small, their old lives they would leave;
the shepherd wanted them all, they just had to believe.

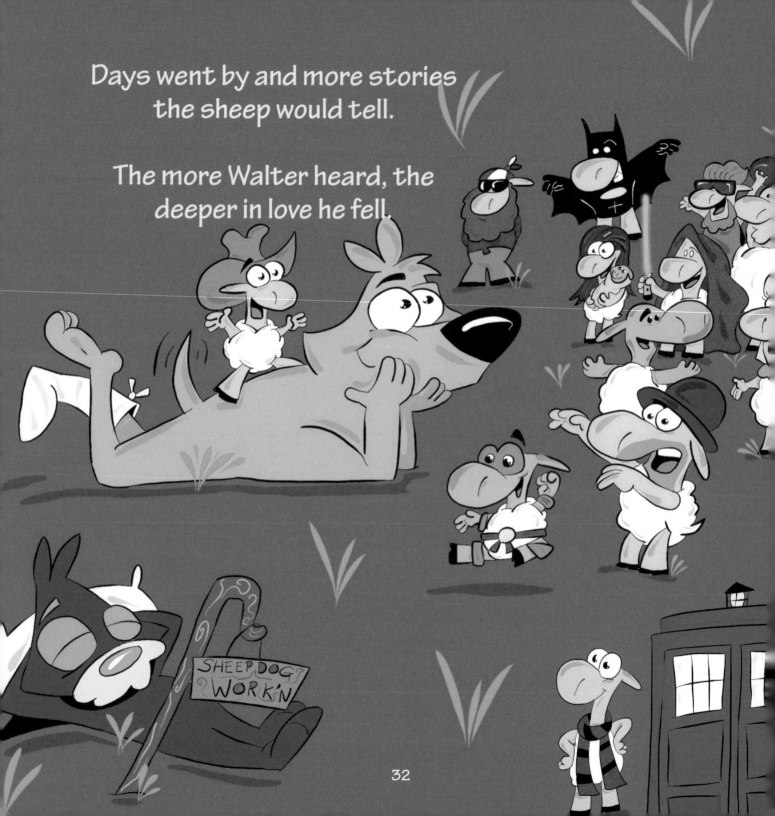

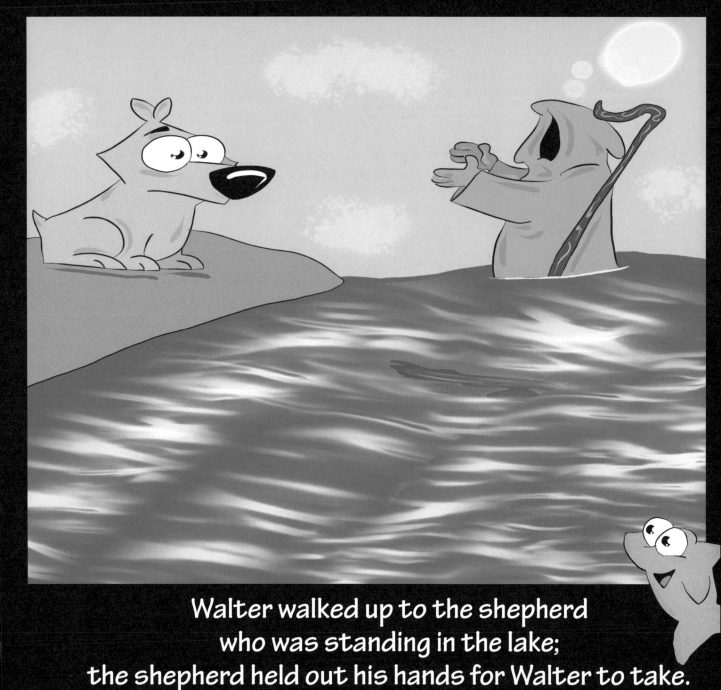

Walter walked up to the shepherd
who was standing in the lake;
the shepherd held out his hands for Walter to take.

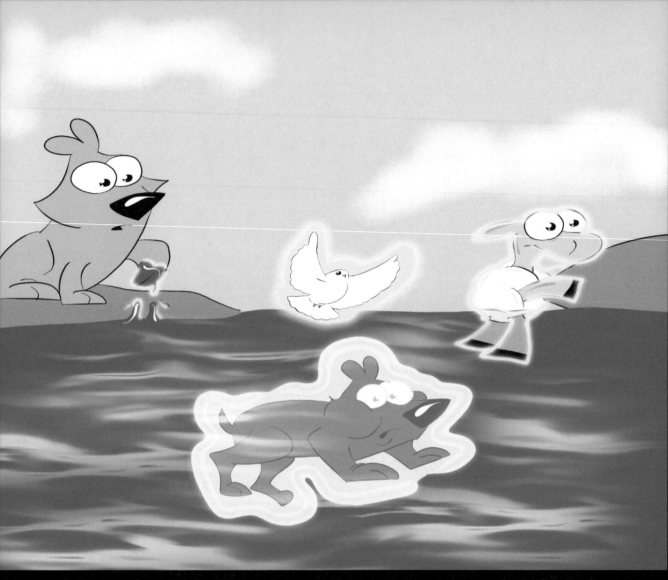

Walter trusted the shepherd, and so he took the leap;
he went under the water and when
he came up, he was a sheep.

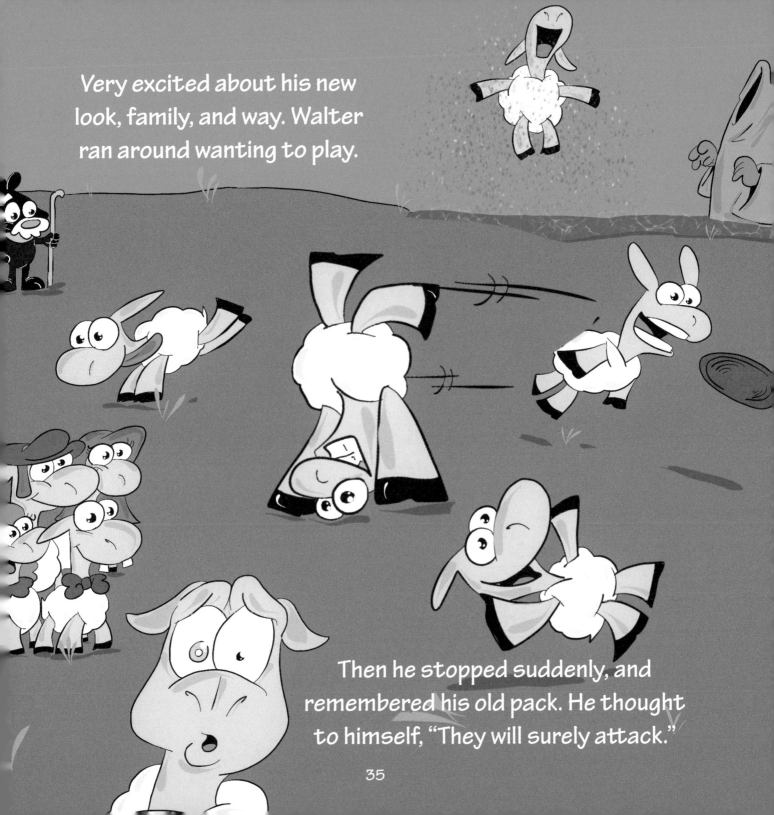

Very excited about his new look, family, and way. Walter ran around wanting to play.

Then he stopped suddenly, and remembered his old pack. He thought to himself, "They will surely attack."

35

He ran down the hill, through the
woods, and pass the trough.

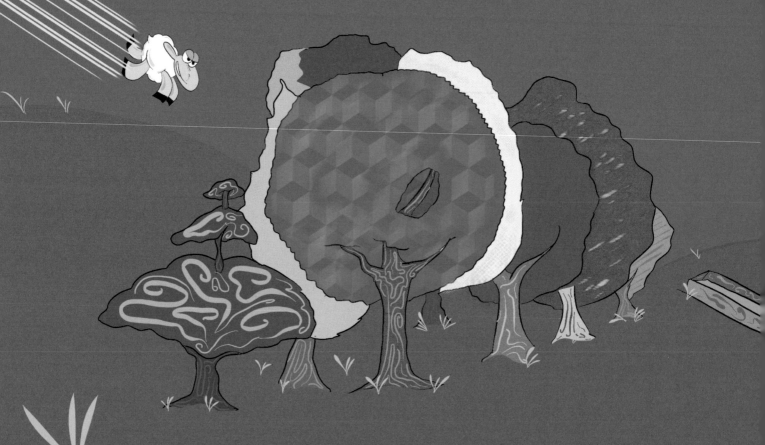

He did not know how,
but he had to defend them off.

He stopped running and realized it was too late;
the wolves were already circling him, enclosing his fate.

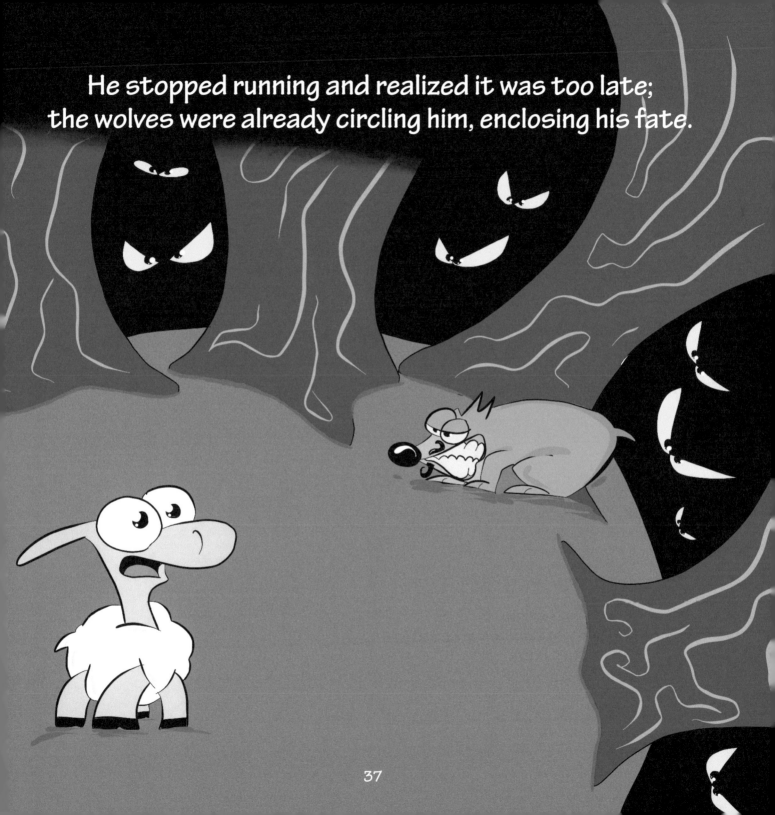

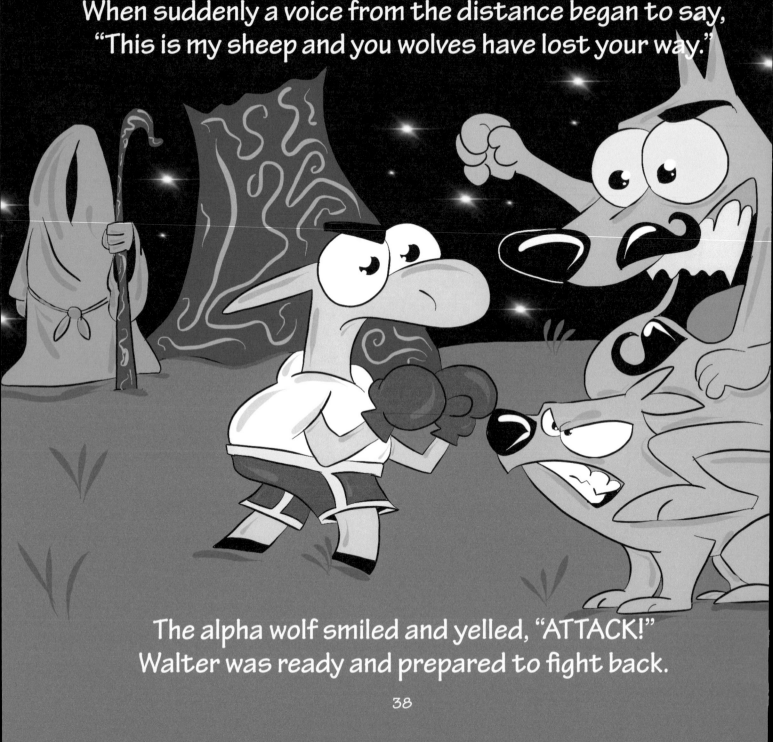

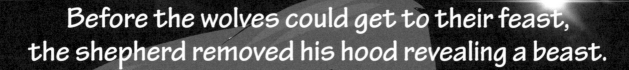

Before the wolves could get to their feast,
the shepherd removed his hood revealing a beast.

With a roar that echoed and shook the ground,
the pack retreated homeward bound.

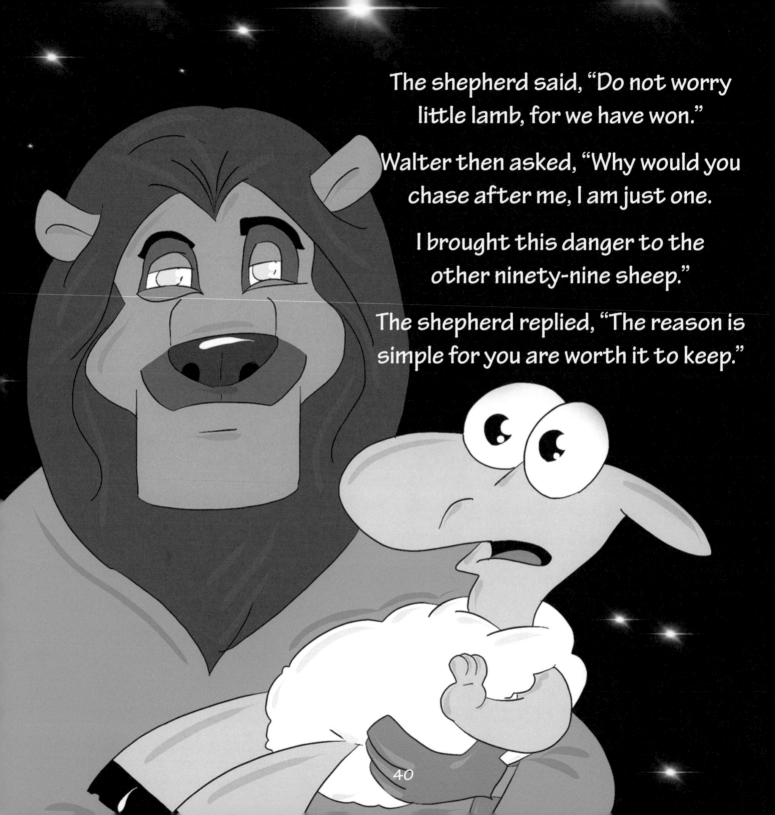

The shepherd said, "Do not worry little lamb, for we have won."

Walter then asked, "Why would you chase after me, I am just one.

I brought this danger to the other ninety-nine sheep."

The shepherd replied, "The reason is simple for you are worth it to keep."

Walter smiled big and whispered,
"This shepherd is mine."
The shepherd smiled back and said,
"I am, for all of time." THE END

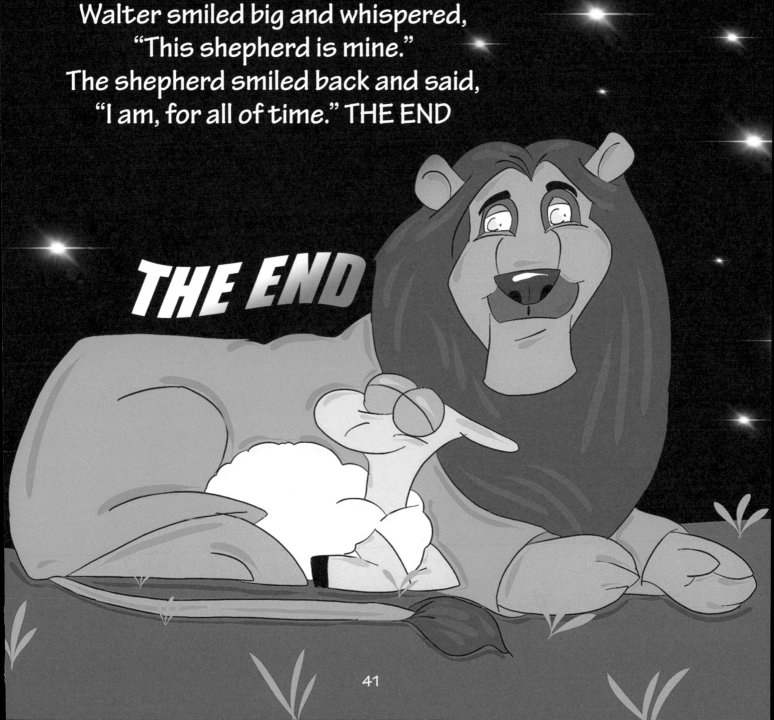

Honorary discharged from the U.S. Army and a practicing nurse for nearly 12 years. I've always have had a passion for drawing and writing, and have always wanted to make my love for GOD a real tangible thing for my young children. It just made sense to write and illustrate a Christian oriented children's book. I live in new Braunfels, Texas with my beautiful wife & five wonderful children.

Printed in the United States
By Bookmasters